Etruscan
Bronze Utensils

SYBILLE HAYNES

PUBLISHED FOR

THE TRUSTEES OF THE BRITISH MUSEUM

BY

BRITISH MUSEUM PUBLICATIONS LIMITED

PRINTED IN GREAT BRITAIN AT
THE UNIVERSITY PRESS
ABERDEEN

Etruscan
Bronze Utensils

List of Plates

5

The writer wishes to thank Miss M. O. Miller for drawing the map of Italy and figures 1 and 2.

Etruscan
Bronze Utensils

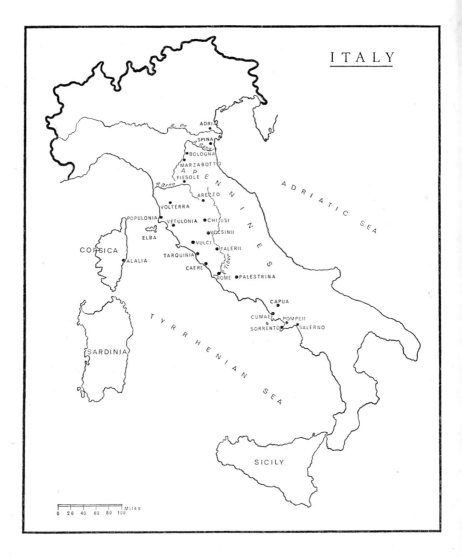

ITALY

R. Po
ADRIA
SPINA
R. Reno
BOLOGNA
MARZABOTTO
A P
FIESOLE
R. Arno
AREZZO
ADRIATIC SEA
VOLTERRA
A P E N N I N E S
POPULONIA
VETULONIA
CHIUSI
ELBA
VOLSINII
VULCI
FALERII
CORSICA
TARQUINIA
R. Tiber
ALALIA
CAERE
ROME
PALESTRINA
CAPUA
CUMAE
POMPEII
SORRENTO
SALERNO
TYRRHENIAN SEA
SARDINIA
SICILY

Miles
0 20 40 60 80 100

8

Historical Introduction

The Etruscans were skilful and inventive bronze-workers whose fame in this field was already well established in Classical Greece. Athenian connoisseurs praised Etruscan gold cups as the best of their kind, 'but also their bronzes of every sort for the decoration and service of houses'. (Athenaeus. Deipnosoph. I, 28 b.) The high esteem in which these bronze utensils were held in antiquity will, we hope, be shared by those who look at the small choice of such objects from the British Museum's collections presented in this booklet. Whether precious ornament, humble household implement or funerary gift, the same liveliness and vivid imagination informs their figurative adjuncts. An exuberant taste for rich embellishment distinguishes Etruscan bronze utensils from the quieter, chaster Greek bronzes preserved in our museums; indeed, it seems to characterize Etruscan art as a whole from the very moment when the Etruscans first emerge from the highly complex ethnic pattern of Iron Age Italy as a distinct people.

In the course of the 8th century B.C. the so-called Villanovan settlements in the area bounded by the Tyrrhenian Sea and the rivers Arno and Tiber appear to have expanded and become materially richer. Without a break but with gradual modification Villanovan civilization in this region evolved into early Etruscan. Among the most important early Etruscan centres were those strung out along the coast of the Tyrrhenian Sea (which still bears the name by which the Greeks called the Etruscans): Tarquinia, Caere, Vetulonia, Populonia and Vulci. Since it was the custom in antiquity when burying the dead to place beside them the most cherished objects of daily life and of personal adornment, it is in the cemeteries of these cities that we can observe the first flowering of Etruscan art. Many of the luxury objects of gold, silver, ivory and bronze deposited with the dead in their tombs were certainly imported

9

from the Eastern Mediterranean; but there were other objects which are clearly copies of such exotic works made by local Etruscan artists on whom the motives and stylistic peculiarities of eastern art exercised a profound influence throughout the 7th century B.C., the so-called 'Orientalizing period' of Etruscan art.

The obvious prosperity of the Etruscan coastal towns at this time was probably due to the exploitation of the rich metal mines in the Tolfa and Allumiere mountains and in the neighbourhood of Populonia, as well as to the skill and enterprise of Etruscan sailors who traded extensively with Greece and the Near East, and were also redoubtable pirates. Etruscan supremacy in the Tyrrhenian Sea was decisively asserted when, about 540 B.C., in league with the trading nation of Carthage, their navy defeated the Greeks of Phocea in a battle off Alalia in Corsica which thus came under Etruscan influence. But their advance to the south was checked by the maritime power of the Greek colonies established in Southern Italy since the 8th century B.C.

From Central Italy the Etruscan cities (sometimes in alliance with one another, sometimes acting independently) extended their dominion to the north as far as the Reno and Po valleys, where Bologna and Marzabotto were amongst their most important foundations. Flourishing centres also sprang up in Campania in the south: at Capua, Pompeii, Sorrento and Salerno, for example, of which some at least go back to the Villanovan and Orientalizing periods.

This great expansion which took place in the course of the 6th and early 5th century B.C., brought Etruria into direct contact with Greek civilization, and Etruscan art was now invaded by successive waves of Greek influence which obliterated the last traces of the earlier Orientalizing phase. In the main the new impulses resulted from the large-scale import of Greek goods, but occasionally, as we know from ancient literary sources, Greek artists settled in Etruria and their workshops must have played an important part in the formation of Etruscan taste. During the early 6th century B.C. the chief inspiration was that of archaic Greek art of the Peloponnesian and South Italian schools, but from the middle of the century onwards the influence of the Greek cities of the coast of Asia Minor is paramount, and after about 490 B.C. that of mainland Greece and of Athens in particular. Throughout this period the

Etruscan artists were not mere copyists, but absorbed and remodelled their Greek prototypes and produced some of their most inspired work under this stimulus.

In the middle of the 5th century B.C. a gradual decline set in, which lasted until the end of the 4th century B.C.: creative powers flagged and instead of responding to the developments of the mature classical style of Greece, Etruscan artists were content to repeat formulae which had been current for a century or more before. No doubt this stagnation was in some measure due to a series of military defeats which Etruria suffered at the hands of her neighbours.

Land communication with Etruscan Campania was cut when in 504 B.C. the Latins, helped by Aristodemus of Cumae, defeated an Etruscan army at the battle of Aricia. Thirty years later Etruscan sea-power and commerce received a crippling blow from allied Greek naval forces off Cumae (474 B.C.). And finally the southern outposts of Etruria were conquered by the Samnites, Italic mountain tribes from the Appennines whose invasion of Campania culminated in the overthrow of Capua in 423 B.C.

Rome which had for long been under the cultural influence of Etruria and was actually ruled by Etruscan kings in the second half of the 6th century B.C., cast off the foreign yoke at the end of this period and expelled the Tarquins from her territory. During the 5th century the young republic carried on an intermittent war of annexation against the Etruscan homeland and in 396 B.C. captured Veii, the most powerful city of southern Etruria. At the same time most of the Etruscans' northern settlements in the Po Valley were lost to invading Gaulish tribes. The Gauls went on to cross the Appennines and ravage the Etruscan countryside and even sacked Rome; but they finally withdrew without attempting any permanent conquests in Central Italy, and the Romans resumed their attacks on Etruria proper. Rent by internal social troubles and preoccupied by political rivalries between each other, the Etruscan cities failed to make a common front against this relentless encroachment, and by the close of the 3rd century B.C. Etruscan independence was virtually at an end. Yet, though the Etruscans were henceforward a subject nation, their creative gifts were to flourish once more, revived by contact with the Hellenistic art of the Greek cities of Southern Italy and of Greece itself, which

as a result of Roman patronage became an all-pervading influence in the second and first centuries B.C.

From this brief account it will be clear that Etruscan civilization owed a great deal to alien inspiration over the centuries; but her artists' response to it was always highly individual and unfettered by aesthetic canons. In the following pages we shall be able to observe how Etruscan craftsmen transmuted their foreign prototypes and adapted them for the embellishment of their bronze utensils, creating a lively and unmistakable style in the process.

Etruscan Bronze Utensils in the British Museum

We begin with a bronze vessel whose decorative motives and forms are still firmly rooted in the Villanovan tradition, the tripod bowl on Pl. I (bottom). The bowl, like the bodies and lids of most ancient vessels, is made of thin bronze sheet hammered to shape; but the feet are cast solid by the so-called direct lost wax process. An exact model of each foot was first made in wax and enclosed in a mould of fireproof clay. Next, the wax was melted out through holes left in the mould for this purpose and the hollow space vacated by the wax was filled with molten bronze. Lastly the mould was broken open to release the foot which was brought to a finish by tooling. The feet end at the top in flat circular plates fixed to the bowl by rivets; below this each is decorated with the geometrically stylized figures of a horse and rider and of a duck. Though the modelling of the figures is highly simplified, the horses are spirited creatures with thick manes and tall pointed ears. Originally they had reins formed by chains of thin bronze strips, remains of which can be seen between the animals' muzzles and the struts supporting them. Similar strips were also used to represent the riders' arms and vestiges of them are still visible in the small holes at their shoulders. But the flat bodies of the men were always legless and their only substantially modelled part is the head with a crudely notched nose and a pyramid headdress. Since this headdress recalls the bronze helmets or terracotta models of helmets used as covers of cinerary urns in Villanovan tombs, it suggests that the horsemen are probably warriors. A number of bowls resembling ours have been found at Vetulonia and Tarquinia in tombs datable to the 7th century B.C. Although our bowl is said to have come from Capua, it is very like an example excavated at Vetulonia in the so-called Tomba di Bes; and we may assume that it, too, was made in this city in the first half of the 7th century B.C.

The small head of a youth on Pl. 1 (top) comes from the collection of Richard Payne Knight which was formed, mainly in Italy, in the late 18th century and left to the British Museum in 1825. The head has a hollow moulded base and must have been a finial for some wooden object, perhaps a staff or an upright member of a piece of furniture, to which it would have been attached by nails passing through two holes in the base. The strange irregularity of the face suggests that the craftsman who made it was grappling with new problems. Under the stimulus of works of art imported from the Near East, where the human face and figure had for long been favourite themes of sculptors and bronzeworkers, Etruscan artists of the second half of the 7th century B.C. gradually abandoned the small scale and the wiry geometric conception which had governed Villanovan figures, and tried to give volume and anatomical detail to their creations. The maker of our little head was inspired by a prototype of a special kind: the human-headed, winged handle-attachment of a large bronze cauldron. The earliest cauldrons with such attachments were manufactured either in North Syria or in the neighbourhood of Lake Van in Eastern Anatolia during the late 8th and early 7th century B.C. and were widely exported. Greek artists soon imitated them, but the attachments of their versions were distinguished by a livelier expression, by more pointed noses and chins, and by the characteristic treatment of the hair which falls down to the shoulders in a stylized wig-like arrangement of horizontal bands. Our Etruscan craftsman has rather clumsily adapted such a handle-attachment to his own purposes; it dates from the later 7th century B.C.

Another decorative motive which reached Etruria from the East through Greek intermediaries during this Orientalizing period, was the griffin, a fabulous beast composed of elements of such various creatures as the eagle, lion and horse. In the course of the 7th century B.C. Greek artists had evolved from oriental prototypes a characteristic kind of griffin head which was also used for the adornment of bronze cauldrons. Greek griffin cauldrons, most of which were made on Samos, became even more popular than those with human-headed handle-attachments and have been found all over the Mediterranean area. Griffin heads from cauldrons of Greek manufacture were exported to Etruria, as we know from examples which have come to light in the Etruscan towns of Perugia,

Tarquinia and Brolio; and the heraldic splendour of these ferocious creatures tempted Etruscan artists to imitation.

A pair of Etruscan griffin heads from Chiusi is illustrated on Pls. I & 2. The deep rectangular sockets in which they end show that they were intended to be attached to wooden poles, possibly carriage-shafts. The heads possess many of the characteristic features of their Greek models: gaping beaks with upward curling tongues, pointed horse's ears joined by a fold of skin passing under the throat, and a tall moulded knob on top of the cranium. But for all their menace these are tamer beasts than the Greek griffins, lacking their keenly arched brows and glaring, inlaid eyes. And when the Etruscan artist copied the incised scale-pattern and the spiral plumes which decorate the neck in Greek examples he mistakenly turned the scales upside-down and made the plumes curl forwards instead of backwards.

The griffins from Chiusi, which must have been made about 600 B.C., are amongst the earliest Etruscan bronzes to be cast hollow. To achieve a hollow casting the bronze-worker probably used a process developed from that which we have already described in connection with solid casting. The process requires the model to be made not of solid wax, but of wax shaped over a clay core and studded with a number of nails or 'chaplets' driven into the core but left with their heads projecting above the wax. As in the simpler process the model is next invested in a clay mould and the wax is melted out, leaving the core suspended inside the mould by the chaplets. Lastly the space between mould and core is filled with molten bronze and when it has set, the mould is broken open to release the casting and as much of the core as can be reached is raked out of its interior. The necks of our griffins still contain remains of the core, a greyish, sandy substance, baked hard by the white-hot bronze.

During the 6th and 5th centuries B.C. Etruscan sovereignty, as we have seen, extended over Campania and Campanian workshops produced a series of admirably decorated bronze funerary urns in a style inspired by both Greek and Etruscan art. The finest of these is the large *dinos* or cauldron on Pls. II, 3 & 4 which was excavated at Santa Maria di Capua in 1847. It was found together with a red-figure cup by the Athenian vase-painter Euergides in a hollowed-out block of volcanic stone covered by a stone slab; a circumstance which explains the excellent preservation of its delicately modelled figures.

15

FIG. 1.

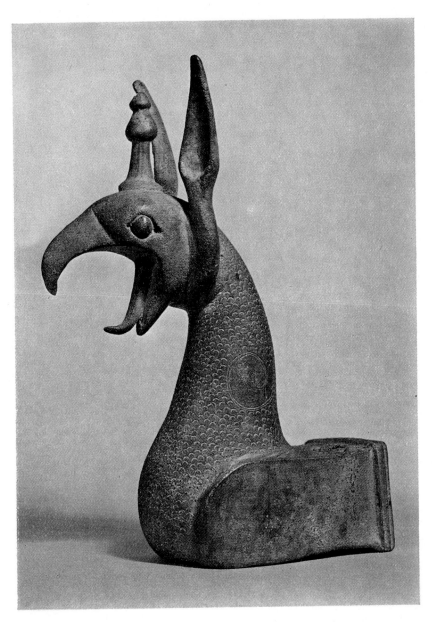

PLATE I. Head of a griffin. From Chiusi (Bronze 391).

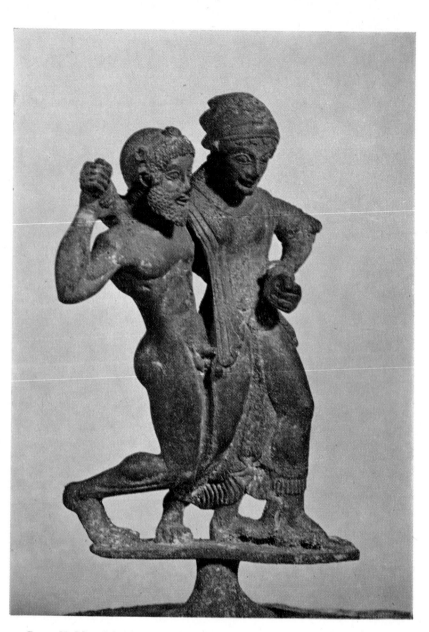

PLATE II. Man abducting a girl. Handle of the lid of an urn. From Santa Maria di Capua Vetere (Bronze 560).

The body and lid are made of hammered bronze sheet, and an engraved frieze decorates the shoulder (fig. 1). Part of the frieze is composed of running, fighting and confronted animals among trees, conventional motives inherited from the Orientalizing period. But next to these appears a remarkable mythological scene: Hercules with lion's skin, club and bow drives off seven bulls or cows to the right, while behind him is a tree on which a man hangs miserably suspended by his wrists and ankles. In all probability this represents an early version of the Italic myth of the thief Cacus who stole the herd of Geryoneus from Hercules, but was caught by the hero and put to death. Further round the vase we see two athletic scenes framed by Doric columns: on the left a lively chariot-race in which six two-horse teams compete; on the right two boxing matches watched by a trainer and accompanied by a flute-player and, beyond these again, a pair of wrestlers. The shape of the chariots and the short tunics of the charioteers are typically Etruscan, and the whole animated scene recalls the wall-paintings of the recently discovered *Tomba delle Olimpiadi* at Tarquinia. Etruscan, too, as we know from Athenaeus (4.154; 12.518), was the practice of boxing to the sound of the flute.

The rim of the vessel and the figures surmounting it are cast solid, the four Amazons being made separately from their horses and fastened to them by pins. The Amazons are dressed in the traditional costume of their war-like sisterhood: over a tightly fitting, patterned under-garment they wear brief leather jackets, trunks and knee-caps, and their heads are covered by soft Phrygian caps beneath which their hair falls in long tresses. They have quivers on their backs and shoot with bows made of bronze wire, two aiming forward and two backward. Their vigorous little mounts turn their heads alertly outward as they trot round the rim. The horses' manes and long tails are carefully trimmed and waved, and holes in their muzzles show that they once had reins of bronze wire. The two figures on the lid—a naked man of muscular build abducting a richly dressed girl—are on a slightly larger scale than the others and served as a handle. Although the girl makes a show of repulsing the man, she does not seem unduly alarmed; and her unruffled clothes, his neat hair and beard, and the calm expressions of both suggest a formal dance movement rather than an actual struggle.

The cast figures seem all to have been made by a single artist, an

17

accomplished master who was probably inspired by Greek vase-paintings, but has created an original and charming work of distinctively Campanian flavour. The incised frieze, on the other hand, whose close connction with Etruscan painting we have already noted, must be by a different artist. But both men doubtless worked in the same workshop, which must have been active during the last decade of the 6th century B.C.

In Etruria proper one of the most prolific bronze-working centres at this time was Vulci which produced, amongst many other things, a characteristic type of incense-burner with elaborate figure decoration, of which an example is illustrated on Pls. III, 5 (left). Its three feet in the form of lion's paws resting on the backs of tortoises are a sure indication of its origin, for composite feet of this kind, often with frogs in the place of tortoises, are typically Vulcian. Here each foot is surmounted by a small couchant lion, an additional embellishment recalling the riders on the Villanovan tripod-bowl. On a small triangular platform rising above the three feet a dancing-girl moves to the left, balancing on her head a tall shaft composed of ornamental discs and reels, which was originally crowned by a shallow bowl to hold the burning incense. The girl glides along with measured step, raising her bent arms in the graceful attitude of an accomplished equilibrist. She wears pointed laced boots, and a clinging embroidered dress buttoned on the shoulders and sleeves. An intricately tied sash encircles her waist, its ends flying out like wings as a result of her movement. Her hair is covered by the tall, conical Etruscan head-dress, the *tutulus*, over which a kerchief is draped. She has disc-shaped earrings, thick bracelets on her arms, and a long twisted necklace from which dangles a lion's-head pendant. The girl's soft delicately modelled features recall those of the Ionian Greek women of the coast of Asia Minor, a female type much loved by Etruscan artists of the second half of the 6th century B.C. She must be one of the tumblers and dancing-girls who, as we know from Etruscan tomb-paintings, performed at funerary games and during banquets. Comparison with draped dancing figures on such paintings allows us to date this incense-burner to about 500 B.C.

A type of utensil well represented in most collections of Etruscan bronzes is the engraved mirror. The invention of polished metal discs to serve as mirrors was made by the Egyptians about 3000 B.C.; before then the only way a lady could see her reflection would have

been by looking in a calm pool or a bowl of water. From Egypt the invention spread to the Near East, and thence to Greece and Etruria, Etruscan mirrors being especially notable for the decoration of their unpolished backs with incised figures or, more rarely, with figures in very low relief. The earliest of the engraved Etruscan mirrors date from the later 6th century B.C. and are circular bronze discs with tangs at the bottom which were fitted into handles of carved ivory, bone or wood.

The bronze mirror on Pl. 6 was made in the beginning of the 5th century B.C. and is one of the most exquisite to have come down to us. It is cast and has on its back a delicate decoration in relief, some details being finely engraved and others inlaid with silver. In the centre is a group of two figures admirably adapted to the circular form: Hercules carrying off the girl Mlacuch (as the Etruscan inscriptions *Herecele Mlacuch* between their feet tell us). The powerfully built hero, wearing the customary lion's skin tied round his neck and holding his club in his right hand, bends under the weight of his captive whom he has caught round the waist and lifted half on to his shoulder. The girl lightly touches the crown of Hercules' curly head with her left hand and her right hand reaches down to his waist, while her legs dangle helplessly in the air. Despite the violent action her clothes—a finely pleated sleeved *chiton* and an embroidered cloak—fall in decorous and elegant folds. Behind Hercules, at the edge of the circle, we see his quiver and below it his bow, impedimenta which the hero must have laid aside to have one hand free for his task. We cannot tell whether Mlacuch is goddess, nymph or mortal, since her name is not known to us from Greek myth; thus Hercules' adventure with the girl remains an unexplained episode of Etruscan lore.

Our mirror is said to have been found at Atri in the Abruzzi, but it cannot have been made there. In all probability it is a product of Vulci, whence comes an inlaid mirror of closely comparable technique, which is now in the Vatican Museum and has for subject the abduction of the beautiful youth Cephalus by Eos, the Dawn. One might, in fact, be tempted to hazard a further conjecture. Among the multitude of Greek vases which have come to light at Vulci is an amphora by the Attic vase-painter Phintias representing Tityos carrying off Leto. So closely does this scene resemble that of Hercules and Mlacuch on the mirror—even in such small details as the

arrangement of the woman's hair and of the weapons suspended near the left-hand margin of the field—that we cannot help wondering whether the man who made the mirror might not have seen this very vase.

Certainly from Vulci is the splendid bronze amphora shown on Pls. IV & 7, a two-handled vessel intended to hold wine or water, which was made between 480 and 460 B.C. Each of the handles is in the shape of a naked, long-haired youth, his powerful body bent backwards in a taut arc, his feet standing on a siren perched on a palmette, and his arms raised to grasp the tails of two couchant panthers fitted to the rim. The quality of the modelling is at once sensitive and strong, and the facial type of the figures and details of the floral ornament find many parallels on other bronzes discovered in the necropolis of Vulci. Like the mirror on Pl. 6 the amphora is embellished by the application of precious metal. Round its wide rim runs a double line of spirals overlaid with a strip of silver, and faint traces of an applied pattern of upright and pendant buds are still visible at the bottom of the neck.

As to the meaning of the figurative scheme of the handles we can only speculate. The figure of the youthful panther- or lion-tamer (other animals are occasionally substituted for the more common felines) may have originated in Oriental representations of the Mesopotamian hero Gilgamesh, who is often shown with two lions heraldically disposed on either side of him. Similar figures—usually referred to as 'Master of the Animals'—occur in early Greek reliefs and vase painting and may have inspired the Peloponnesian artists who first produced bronze vases with anthropomorphic handles of this type. From Greece this scheme passed to South Italy and Etruria where it was popular until the middle of the 5th century B.C. The sirens—part sweet-voiced women, part birds—were mythical creatures associated with death. As such they were frequently represented on the bronze water-jugs used by the Greeks in the cult of the dead. On our amphora, however, on which they occupy only a subordinate position, their function is probably purely decorative.

Etruscan bronze utensils were not, of course, always of this high quality, and an amphora such as the one we have just been looking at must have been a precious rarity even in its own day. The vast majority of implements were more modestly fashioned. A good

example of a humbler, yet still pleasing, kind of household utensil is provided by the strainer on Pl. 8. As we can see from the banqueting scenes represented on Etruscan limestone reliefs from Chiusi, such strainers were used to keep back the lees of the wine when ladling the liquid from big containers into the drinking cups. The bowl of the strainer is perforated in regular circles at the bottom and has a flat handle which tapers off slightly towards a suspension-ring ending in a double-volute. Where the handle is joined to the bowl the figure of a muscular youth running to the right appears in very low relief above an incised floral ornament. He lifts up both his arms and turns his head as if on the look-out for a pursuer. His nudity and attitude suggest that he is an athlete. It is very likely that the craftsman who made the strainer copied the figure of the boy from some Greek vase-painting of about 500–490 B.C., but since our bronze is a provincial work it may well have been made two or three decades after such figures were fashionable as decorative motives in Greece.

Although the Etruscans occasionally used oil-lamps for illumination, they much preferred candles, for which they evolved a characteristic kind of bronze candelabrum, frequently adorned with human figures. A tomb-painting from the Tomba Golini at Orvieto shows how the long candles were stuck sideways on the upswept prongs radiating from the top of a tall shaft supported on three feet. The feet of the candelabrum on Pl. 5 (right) end in lion's paws, the spaces between them being decorated with inverted palmettes. At the bottom the fluted shaft is sheathed by three superimposed rows of tongue-shaped leaves. The top of the candelabrum is formed by a moulded base bearing the figure of a naked athlete (Pl. 9). He is a broad-shouldered young man who stands in a relaxed attitude with a pair of jumping-weights in his hands. The long jump in antiquity was always executed with the help of *halteres*, jumping-weights, of stone or metal. The purpose of these objects was clearly to increase the body's momentum, though how precisely they were used is debated. Their form varied, but the most usual was a semi-circular slab of metal with a deep recess in the diameter offering a convenient grip for the fingers. A leaden pair of this type, found at Vulci and now in the British Museum, exactly resembles in shape those held by our athlete. He seems to be feeling their weight as he prepares for the jump.

Athletes were a favourite subject for the decoration of candelabra and a considerable number of statuettes of youths with jumping-weights survive. Most closely related to our figure in attitude, build and hair-style is a jumper surmounting a candelabrum from the Guglielmi Collection in the Vatican Museum; and it is interesting to note that both the Guglielmi Collection and the Canino Collection, from which our candelabrum came to the British Museum, consist mainly of objects excavated at Vulci. Both candelabra, we may suppose, were made in the same Vulcian workshop; and since the style of the figures enables us to date them near the end of the 5th century B.C. they prove that Vulci still possessed a flourishing bronze-industry a hundred years after producing the censer illustrated on Pl. 5 (left). But they also attest an incipient carelessness in detail and finish.

In fact, the excellent workmanship of most of the Etruscan bronze utensils we have been looking at so far, is, broadly speaking, characteristic of the later 6th and early 5th centuries B.C. For reasons already touched upon in the introduction, the quality of the bronze-working and, above all, the freshness of artistic invention seem to have flagged a little during the second half of the 5th century and throughout almost all of the 4th. The figurative motives employed tamely repeat and echo schemes of Attic and South Italian Greek art of the classical phase and occasionally even hark back to late archaic types. Because of this mixture of stylistic elements and the summary manner in which they tend to be treated, it is often difficult to attempt a precise dating of the works of this period.

The *patera* or shallow pan on Pl. 10 provides a good illustration of the problem: though the figure of the woman which serves as its handle is modelled with a pleasing freedom compared with most earlier works it lacks their liveliness of conception and meticulous finish. Of its date we can say no more than that the figure reflects a female type of the later classical period of Greek art and cannot therefore be earlier than the middle of the 4th century B.C.

The pan and the handle are cast separately and joined by soldering. The woman steadies the patera with her right hand and rests her left hand on her hip. She stands on a small circular base with a ring underneath it by which the pan could be suspended when not in use. She is dressed in a heavy woollen garment bordered by a

rather carelessly executed line of hatching; this is the Greek *peplos* which was only rarely worn by Etruscan women. Under the peplos appears the *chiton*, a longer robe of thinner, pleated material with sleeves buttoned along the shoulder seams. The slightly gloomy expression of the young woman's face, with its veiled eyes, full lips and heavy chin is characteristic of later Etruscan art. A beaded diadem crowns her thick locks which fall in clusters over her ears and are looped up at the back.

Like the candelabrum (Pl. 5 (right)) the patera comes from the Canino Collection and was therefore probably found and perhaps made at Vulci.

An utensil which seems to have been indispensable for the Etruscan household is the bucket or *situla*, and a great quantity of bronze buckets of various shapes has survived, some plain, others with decorated bodies and handle-attachments. The large and lavishly adorned bucket on Pl. 11, which was found in a tomb at Offida in Picenum, is, however, far too heavy and unwieldy to have been an object of daily use; it must have served some special, perhaps a ritual, purpose. Its cast body, though much mended and backed in recent times, is completely preserved: encircled at top and bottom by elaborate floral friezes it stands on three lion's paws resting on plinths and surmounted by figured reliefs. The subject of all three reliefs is the same: Hercules (the best loved hero of Etruscan art) strangling the Nemean lion. In composition, too, all three reliefs are identical but they vary considerably in detail; possibly the wax models from which they were cast, were themselves formed in a single mould and then touched up individually. Hercules, a beardless, youthful figure with slightly rustic features, wears a metal cuirass with leather tabs fringing its lower edge, and a brief sleeved tunic underneath it. He kneels on the left and bends forward to suffocate the enormous crouching lion, whose tongue already hangs limply from its gaping jaws.

The bucket's two handle-attachments are also cast solid and decorated with figures in relief: a Siren—her human upper body facing outwards and her bird's wings and tail spread in flight— seizes two small naked boys by their wrists. She carries the dishevelled figures up through the air, supporting their weight by holding on to their hips with her claws. Her human face is sternly beautiful, and she wears a girt chiton, drop earrings and a diadem on her

tresses. Above each Siren's head is a pair of rings surmounted by a scallop-shell ornament. The rings hold the two handles of the bucket, twisted bronze rods with upturned ends in the form of lotus buds, which can swivel freely and lie flat on the rim when not in use. The Sirens are spirits familiar to us from Greek Art and literature; they were thought to carry the souls of the dead—usually represented as tiny human figures—into the beyond. In Etruscan art they are relatively rare and we do not know what significance they may have had in Etruscan belief; so that we cannot say that their occurrence on the bucket necessarily implies that it was used for funeral purposes.

The style of the floral friezes and of the figured decoration points to a date in the 4th century B.C. for the bucket.

A subject often and aptly engraved on Etruscan mirrors is that of a goddess or mortal woman performing her toilet with the aid of her maid-servants; and the furniture of the scene sometimes includes a cylindrical box standing on the ground. This box, which is known to archaeologists as a *cista*, was a container for the various objects which Etruscan ladies considered necessary for their embellishment: scent-bottles with dip-sticks, mirrors, combs, hair-pins, scrapers, pluckers and so on.

The cista on Pl. 12 comes from Palestrina—the ancient Praeneste —a hill-town to the south-east of Rome, which was a famous centre for the production of such toilet-boxes, mirrors and other bronze implements. Dating from the end of the 4th century B.C. it is a typical example of the kind of cista made from this time onwards. Its body, which stands on three cast feet, is made of hammered sheet bronze and covered by a slightly domed lid with a figured handle. Small rings fixed round the upper part of the body held chains or strings by which the cista could be carried. The feet are in the form of lion's paws, each surmounted by a kneeling winged boy in low relief, probably Eros, who holds an uncertain object, possibly an inverted torch, in his right hand. The handle (Pl. 13) consists of a satyr and a maenad who stretch out their hands to touch each other and so form a convenient grip. In Greek myth satyrs are spirits of nature, part human beings and part goat or horse, the attendants of Dionysus, the god of wine. The animal nature of our Etruscan satyr is expressed by the pointed ears rising from his carefully trimmed hair and by the small horse's tail at his back. He moves with a lively step towards the

24

maenad who shies away a little before his ardent advance. That she, too, belongs to Dionysus' light-hearted cortège is obvious from her garment: a dappled fawn's skin slung across her body and knotted on her shoulder. The object which she once held in her right hand may have been a *thyrsus*, the ivy-tipped staff which Dionysus and the maenads usually carry.

The lid and body of the cista are incised with themes from Greek mythology, both scenes being taken from the story of Achilles. The lid shows three Nereids or sea-nymphs riding over the crests of the waves on a dolphin and two marine monsters. The girls are companions of the sea-goddess Thetis, the mother of Achilles, and they carry part of the suit of armour which Hephaestus, the smith-god, has made for the hero at his mother's request. The engraving on the body (fig. 2) depicts Achilles sacrificing Trojan prisoners before the funeral pyre of his friend Patroclus, a sombre episode from Book 23 of the Iliad. The goddess Athena and an Etruscan genius of death look on while the hero performs his cruel task. Of his five comrades some hold the naked prisoners fast by the ropes with which their hands are tied, others carry armour to pile on the pyre. The engraving must have been inspired by some well-known Greek wall-painting, for the central group recurs on Greek vases and Etruscan frescoes.

In the contrast between the gay Dionysiac group on the cista's cover and the grim scene incised on its body we have a good illustration of the manufacturing methods of the Praenestine workshops; there can be little doubt that the different parts of cistae were produced by different craftsmen and then fitted together without regard for their reciprocal suitability. Moreover, the handles and feet often hide important parts of the design. The handle figures are frequently of better quality than the feet and must have been modelled by more skilful men; many of the feet, indeed, seem to have been mass-produced, since the same foot is repeated on several different cistae.

A charming and unusual Etruscan utensil is the bronze shovel on Pl.14 which may have been used to carry burning charcoal. It was cast solid in three pieces: the handle, the decorative figure on top of it, and the box-shaped shovel. The handle is fluted and sheathed by a stylized leaf where it joins the shovel. At this end it terminates in a finely modelled ram's head, at the opposite end in that of a lion.

The figure, which was attached to the handle by solder, is that of a young man who sits in a casual attitude with crossed legs supporting himself on his left arm and turning his trunk and head to the left while shielding his eyes as if he were gazing at something in the distance. He wears laced boots and a brimmed, pointed hat, beneath which his hair escapes in wind-blown tresses. The shovel, an oblong rectangle with a turned-over rim, is decorated by a tongue-pattern running round its sides and back. On the flat surface of the curved blade appears a date-palm in an oval cartouche, perhaps the impression of a seal made in the wax model before casting.

The exact provenance of our shovel is not known (it comes from the Payne Knight Collection), but it is very likely to have been made at Praeneste about 300 B.C. The facial type of the youth, his striated hair and the competent stylization of his muscular body in smooth planes, closely connect him with other late 4th-century bronzes known to have come from Praeneste, such as the maenad and satyr from the cista on Pl. 13 and another cista-handle in the British Museum, a three-figure composition (Bronze 643).

Praeneste was still producing fine figured bronzes more than 150 years later, but during this period the proportions of the human body in art had altered. The compact and comparatively simply organized figures favoured by Etruscan artists of the later 5th and 4th centuries B.C. have given way to elegantly attenuated forms and bodies caught in subtle, intricately twisted movements. The slender body of the naked girl on Pl. 15 with her tip-toe stance and delicate torsion reflects the ideals created by the Greek sculptor Lysippus and his Hellenistic followers.

The girl forms the handle of a large *strigil*, or scraper, and herself demonstrates the use of the instrument. With a strigil which she holds in her left hand she scrapes off the oil with which she has anointed herself after exercise or the bath. She wears only soft leather shoes; and since she raises her head and shields her eyes from the sun with her right arm, she must be in the open and we may assume that she is an athlete. Her wavy hair is tied up in a high bun by a fillet and decorated with three flowers. At the back the figure is connected to the curved blade of the scraper by a strut in the shape of a floral stem ending below in three fluted leaves. Two similar strigils, both preserved in the Villa Giulia Museum at Rome,

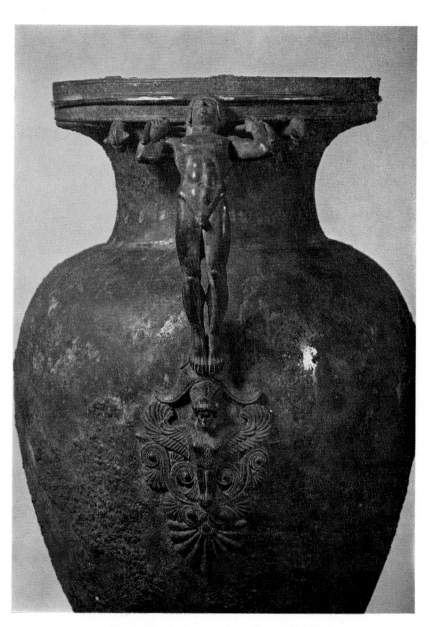

PLATE IV. Youth. Handle of an amphora. From Vulci (Bronze 557).

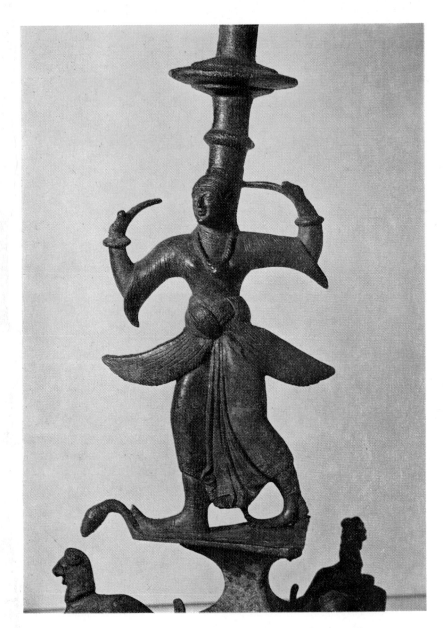

PLATE III. Dancing girl. Part of an incense-burner (Bronze 598).

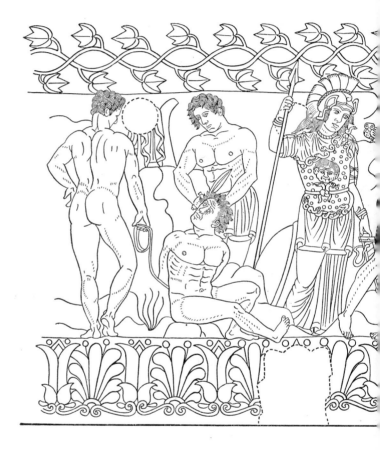

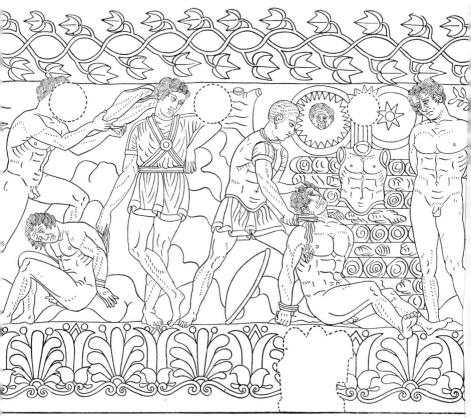

FIG. 2.

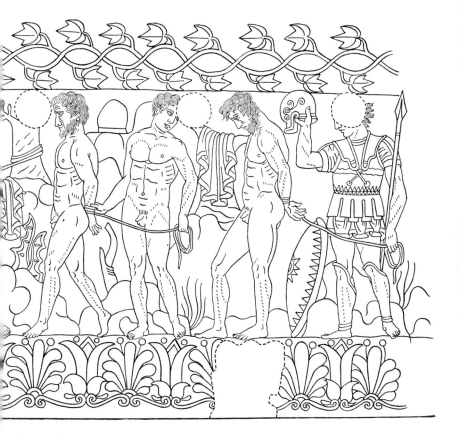

also come from Palestrina; perhaps these scrapers with handles, in the form of girls were, like the cistae, a speciality of the town's bronze industry. Since the blade of our strigil is exceptionally large, it was probably made as a votive object rather than for daily use.

Pl. 16 (top) shows a *balsamarium* or bottle for scented toilet-oil in the shape of a woman's richly dressed head, a type much favoured by Etruscan ladies during the first half of the 2nd century B.C. Like most utensils in ancient households it could be hung up on the wall when not in use; suspension-chains (fragments of which survive) were fixed to two loops formed by confronted dolphins emerging from the woman's locks; a third chain was connected to the stopper of the bottle, which is shaped like a top-knot of hair, and the upper ends of all three chains were originally attached to a ring. The upswept tresses are stylized as a series of vertical ridges held in place by a triangular diadem with a large jewel in the centre. The woman has regular, slightly sullen features with full lips and sharply outlined eyes, the hollow pupils of which were once filled with coloured stone or paste. She wears earrings of rosettes with inverted pyramid pendants, and round her neck a twisted cord is tied from which hangs a crescent-shaped ornament. The flat bottom of the flask was soldered on, but is now missing.

These graceful head-vases may represent Aphrodite, the goddess of Love (*Turan* in Etruscan), or they may be *Lasae*, the Etruscan spirits of beauty, who are often shown in art attendant on divine or mortal women during their toilet—we cannot tell. But their decorative form admirably suits their purpose.

Let us look in conclusion at another incense-burner, of a much simpler type than the elaborate tripod on Pl. 5 (left); a shallow bowl with an egg-and-dart border round its edge and four small reclining figures soldered to the flat surface of its rim, Pl. 16 (bottom). On its underside there are two adjacent loops for suspension in the form of dolphins. The decorative figures—three men and one woman—lean on cushions with their left elbows, while their right arms rest on their hips. All four cross their legs in a comfortable attitude. The men's legs are wrapped in a cloak one end of which is thrown over the left arm, and they wear their hair in a loose fringe. One holds a shallow drinking cup in his right hand. The woman is entirely shrouded in her cloak which is pulled over her head and just discloses the edge of her dress at the neck.

27

Our four banqueters—for such they must be—are reclining round the incense-bowl just as in real life banqueters lay on couches round the sides of the dining-room helping themselves to food and wine from splendid bronze vessels of the kind we have been looking at. Such figures of feasting Etruscans are familiar to us from numerous tomb-paintings and from later Hellenistic Etruscan sarcophagi and ash-urns. The distended, shapeless bodies of the men on our incense-bowl recall the male physique so often represented on the funerary chests of the 2nd century B.C., a type which was, no doubt, responsible for the Romans' taunt of *obesus Etruscus*, the fat Etruscan.

In our brief survey of Etruscan bronze utensils we have been able to trace the outlines of the development of Etruscan art as reflected in one of its humbler branches; and with our last utensil we have reached a point in the later part of the 2nd century B.C., after which Etruscan art loses much of its individuality. Henceforth the art of Central Italy, though flourishing, merely mirrors the Hellenizing art of Rome, which, in the wake of political unification, had brought cultural unity to the whole peninsula.

Select Bibliography

G. Dennis. *The Cities and Cemeteries of Etruria.* 2 Vols. *2nd* edn. London, 1878.

M. Pallottino-Skira. *Etruscan Painting.* Geneva, 1952.

M. Pallottino. *The Etruscans.* Penguin, 1955.

M. Pallottino-M. Hürlimann. *Art of the Etruscans.* Thames and Hudson, London, 1955.

E. Richardson. *The Etruscans.* The University of Chicago Press, 1964.

J. Heurgon. *Daily Life of the Etruscans,* Weidenfield and Nicolson, London, 1964.

P. Ducati. *Storia dell'Arte Etrusca.* 2 vols. Florence, 1927.

G. Q. Giglioli. *L'Arte Etrusca.* Milan, 1935.

L. Banti. *Il Mondo degli Etruschi. Le grandi civiltà del passato.* Rome, 1960.

M. Pallottino. *Etruscologia.* 5th edn. Milan, 1963.

S. Haynes. *Etruscan Sculpture.* British Museum, 1971.

Plates

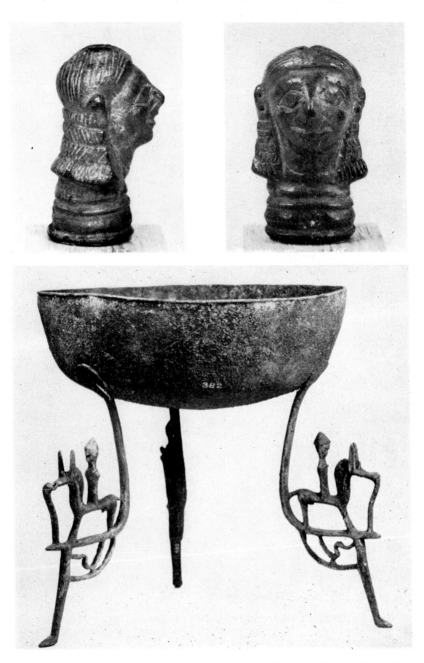

PLATE I. (*top*) Head of a youth. Height: 5·4 cm. Payne Knight Collection (Bronze No. 1958.8-22.5). (*bottom*) Tripod bowl. Height: 20 cm. From Capua (Bronze 382).

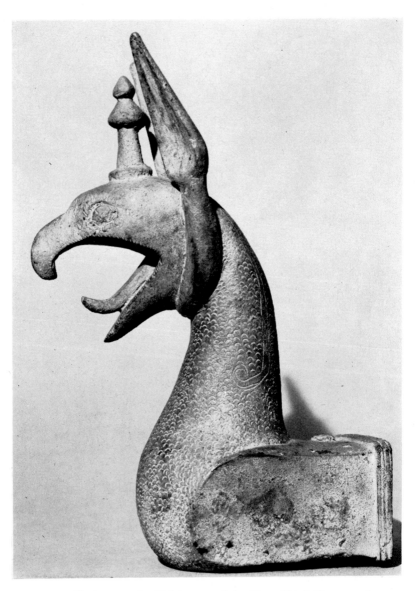

PLATE 2. Head of a griffin. Height: *ca.* 22·8 cm. From Chiusi (Bronze 391).

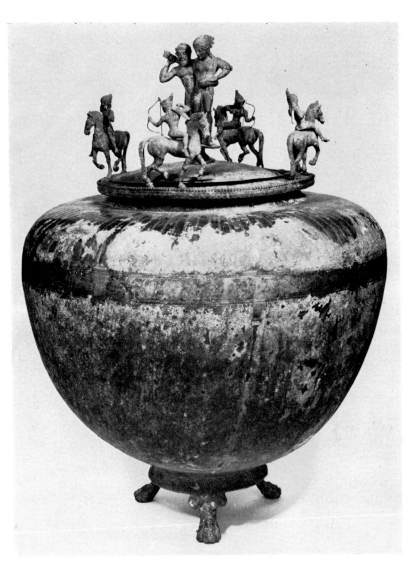

PLATE 3. Urn with figure decoration. Height from break at bottom to rim: 38·5 cm.; height of central group: 13·4 cm; height of Amazons: *ca.* 11 cm. From Santa Maria di Capua Vetere (Bronze 560).

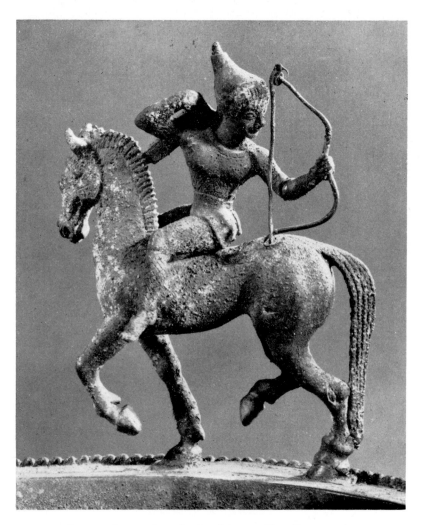

PLATE 4. Amazon from the rim of the urn, Pl. 3 (Bronze 560).

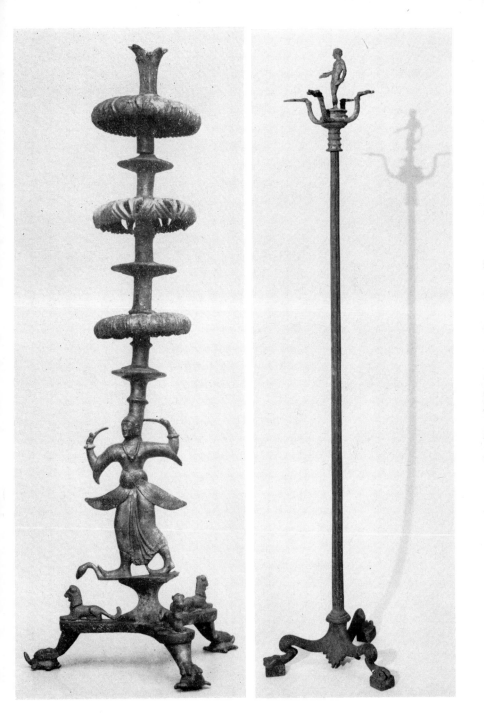

PLATE 5. *(left)* Incense-burner. Total height: 45 cm; height of figure: 12·2 cm. (Bronze 598). *(right)* Candelabrum. Total height: 114·5 cm. Canino Collection (Bronze 668).

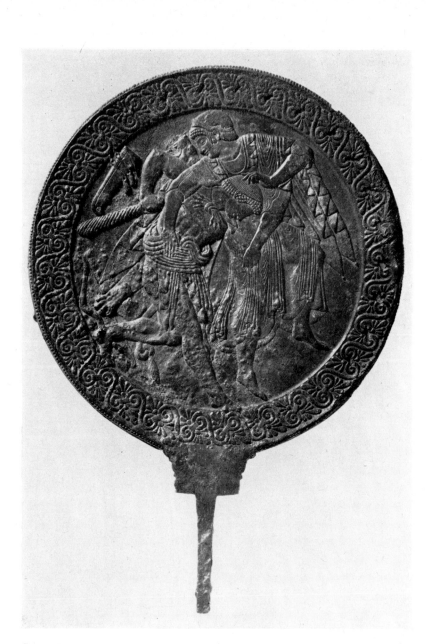

PLATE 6. Mirror. Height: 25 cm.; diameter: 18 cm. Said to be from Atri. Hamilton
Collection (Bronze 542).

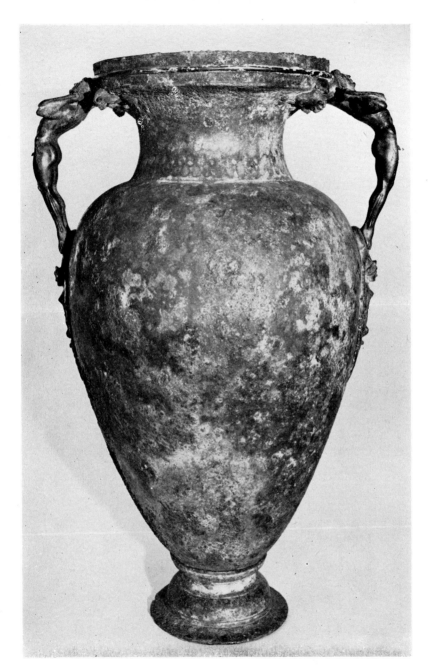

PLATE 7. Amphora. Height: 54 cm.; height of handles: *ca.* 31 cm. From Vulci (Bronze 557).

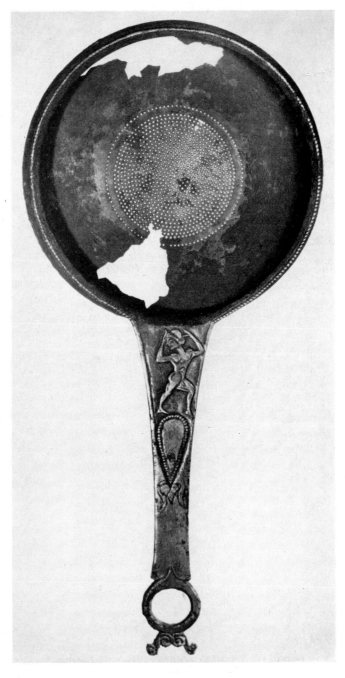

PLATE 8. Strainer. Length: 28·9 cm.; diameter of bowl: 13·7 cm. Payne Knight Collection (Bronze 573).

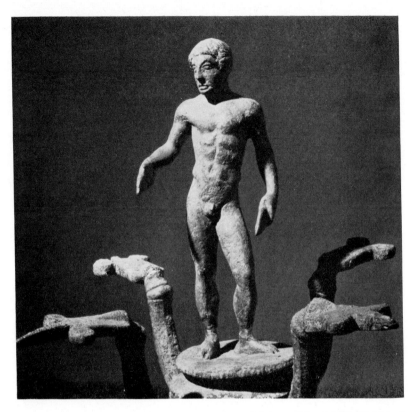

PLATE 9. Youth with jumping-weights. From the candelabrum, Pl. 5 (right). Height of figure: 11·4 cm. Canino Collection (Bronze 668).

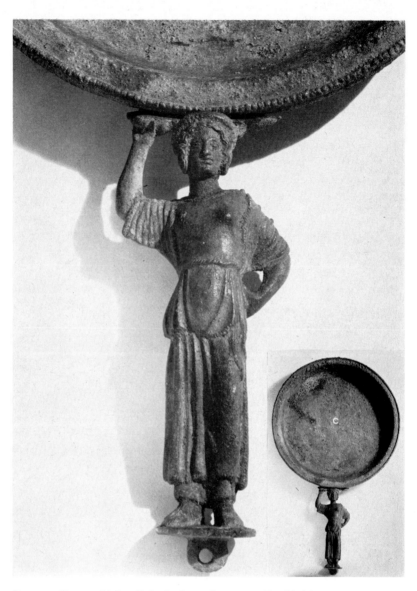

PLATE 10. Patera with handle in the form of a woman. Total height: 35 cm.; height of
figure: 12 cm. Canino Collection (Bronze 659).

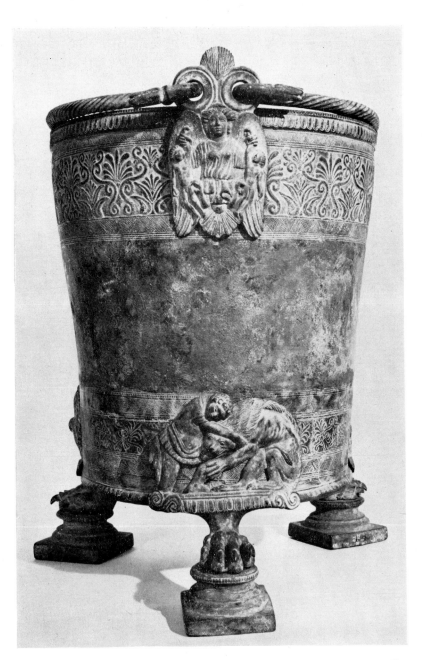

PLATE 11. Bucket. Total height: 46 cm.; height of foot: *ca.* 18 cm.; height of handle-attachment: 14·5 cm. From Offida (Bronze 650).

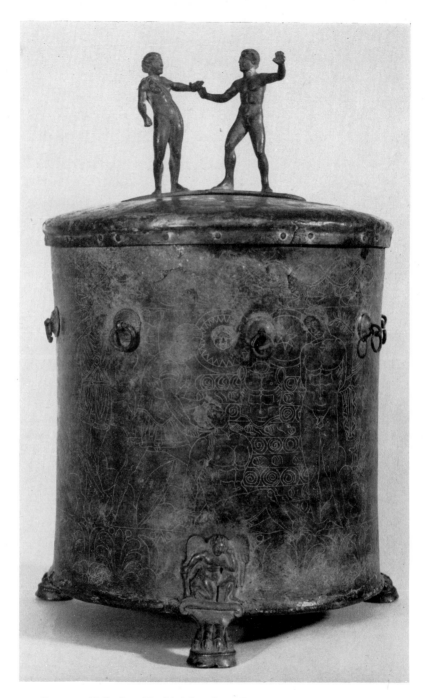

PLATE 12. Toilet-box. Total height: 36 cm. From Palestrina (Bronze 638).

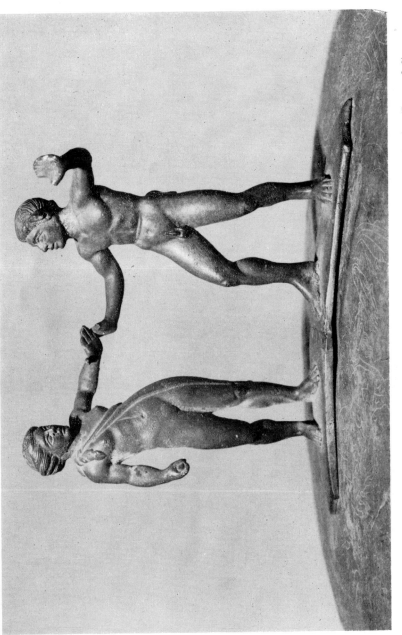

PLATE 13. Handle of the lid of the toilet-box, Pl. 12. Height of figures: *ca.* 9·3 cm. From Palestrina (Bronze 638).

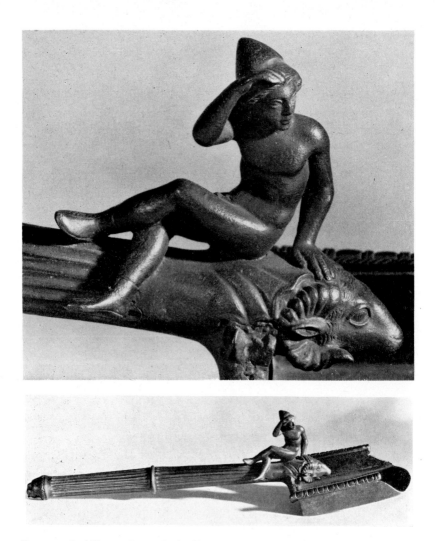

PLATE 14. (*top*) Figure of a youth, detail of the shovel. (*bottom*) Shovel with figure decoration. Length: 37·4 cm. Payne Knight Collection (Bronze 1227).

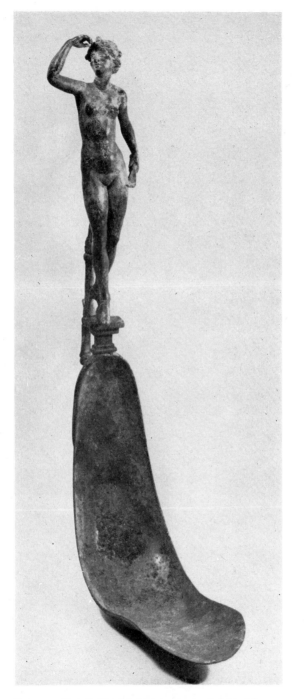

PLATE 15. Strigil. Total height: 41·2 cm.; height of figure:
20 cm. From Palestrina (Bronze 665).

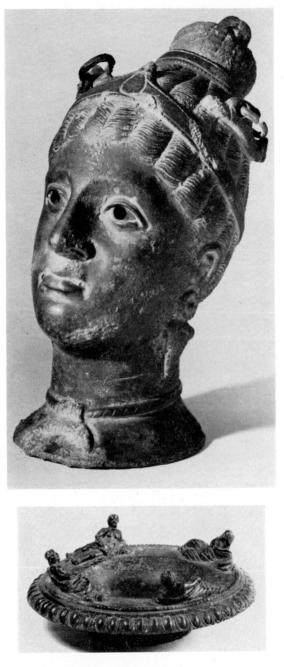

PLATE 16. (*top*) Scent-bottle in the form of a woman's
head. Height: 11 cm. (Bronze 763). (*bottom*) Incense-
burner. Diameter: 12 cm. Hertz Collection (Bronze
2512).